Romare Bearden
Patchwork Quilt

ESTHER ADLER

THE MUSEUM OF MODERN ART, NEW YORK

Romare Bearden (American, 1911–1988). *Patchwork Quilt*. 1971.
Cut-and-pasted fabrics, paper, and gelatin silver print with
acrylic on board, 35 ¾ × 47 ⅞" (90.9 × 121.6 cm). THE MUSEUM OF
MODERN ART, NEW YORK. BLANCHETTE HOOKER ROCKEFELLER FUND

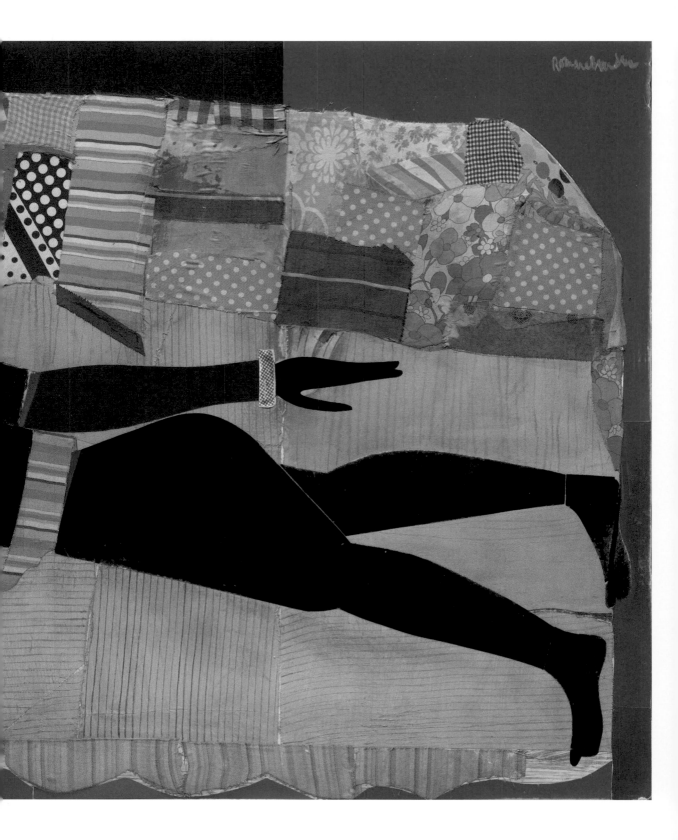

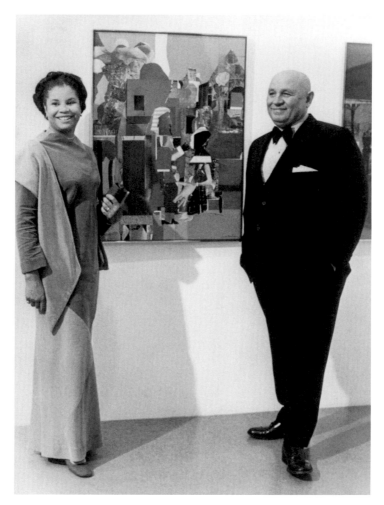

FIG. 1. Romare Bearden with his wife, Nanette Rohan, at the opening of *Romare Bearden: Prevalence of Ritual*, The Museum of Modern Art, New York, March 23, 1971

IN 1971, *ROMARE BEARDEN: THE PREVALENCE OF RITUAL* OPENED AT THE MUSEUM OF Modern Art. It was a significant event: the artist's first solo exhibition at a New York City museum **[FIG. 1]**, and MoMA's first major exhibition of a Black American artist since 1937.[1] The opening party was a suitably celebratory event— photographs show Bearden relaxed and dapper in a tuxedo, among what was for the Museum at that time an unusually racially and culturally diverse group of curators, supporters, and artists **[FIG. 2]**.[2] Bearden was not new to MoMA; his work had been in the collection since 1945, and in 1970, just a few months before *The Prevalence of Ritual* opened, the Museum had acquired *Patchwork Quilt*. It was the first of his celebrated collages to enter the collection and, because of its dynamic palette, was an obvious choice for the cover of the exhibition catalogue **[FIG. 3]**.

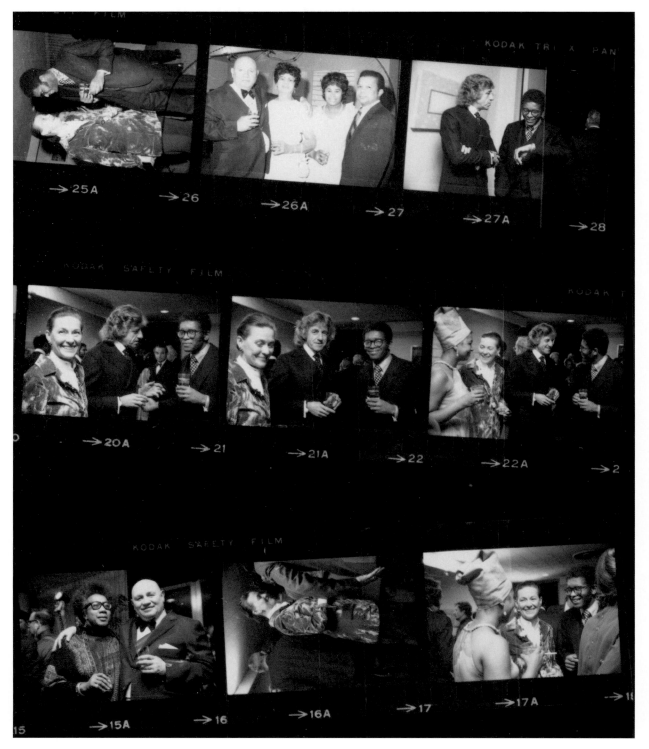

FIG. 2. Frames from a contact sheet of photographs from the opening of *Romare Bearden: Prevalence of Ritual* and *The Sculpture of Richard Hunt*, March 23, 1971. THE MUSEUM OF MODERN ART ARCHIVES, NEW YORK

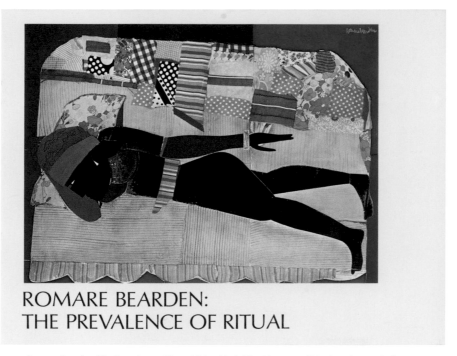

FIG. 3. *Romare Bearden: The Prevalence of Ritual* (New York: The Museum of Modern Art, 1971), front cover with *Patchwork Quilt*

When the young poet and playwright August Wilson came across this book in 1977 and saw Bearden's work for the first time, it left an indelible impression:

> What I saw was black life presented on its own terms, on a grand and epic scale, with all its richness and fullness, in a language that was vibrant and which, made attendant to everyday life, ennobled, affirmed its value and exalted its presence. It was the art of a large and generous spirit that defined not only the character of black American life, but also its conscience. . . . I was looking at myself in ways I hadn't thought of before and have never ceased to.[3]

In this monumental composition, dominated by its prone figure, large swaths of disparate tones and shapes are combined in a unified, striking, and elegant whole. *Patchwork Quilt* is, according to Bearden's biographer Myron Schwartzman "arguably one of his greatest masterpieces in collage."[4] Created three decades into the artist's career, its scale and palette demonstrate his mastery of what had come to be his signature medium, but its departures from previous works signal his creative restlessness. For Bearden, collage was a continuous, iterative

process of experimenting with materials and techniques. Even his most accomplished works, preceded by decades of artistic and personal exploration, contain new developments and surprises, the result of his lifelong commitment to expanding his craft.

The Prevalence of Ritual opened during a tense moment in the art world, when Black artists in New York were forcefully voicing their discontent with the city's major institutions. Less than a year before Bearden's exhibition, demonstrators outside MoMA had protested the blatant racism behind the Museum's failure to include the cultural contributions of artists of color [**FIG. 4**]. The external pressure proved effective: the Bearden exhibition was scheduled, and an outside Black consultant, the curator Carroll Greene, was hired to organize it. It would be a mistake, however, as well as a disservice to Bearden, to give sole credit to social and political activism for the belated appreciation of his extraordinary career. His work speaks powerfully of specific and often disregarded experiences, but it also makes those experiences broadly accessible and argues for them as universally relevant. The exhibition, though modest in size and incomplete in scope, was nonetheless a major event: the recognition of one of the greatest American artists of his generation by the most elite contemporary-art institution in the world. It was a milestone for Bearden, and for MoMA.

Bearden's generous spirit, the one Wilson perceived in his work, was evident even at this moment of personal accomplishment and celebration. Recalling the

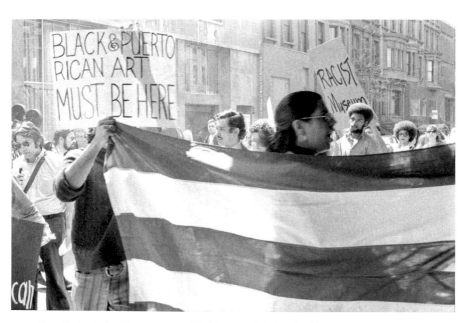

FIG. 4. Guerrilla Art Action Group protest at The Museum of Modern Art, May 2, 1970

MoMA opening, the artist Benny Andrews wrote to Bearden three years later, "I shall never forget the feeling I received from you and the sensitivity you showed towards the fact that other Black artists like Hale Woodruff, Norman Lewis and others were not sharing the same kind of honor that you were at that particular time."[5] Bearden's career and life were characterized by his commitment to the Black community and to sharing his platform and his knowledge with those around him. This had been apparent even in his youth. As a talented baseball player in college, he had been offered the opportunity to play professionally, but the offer came with a caveat: he would have to agree to pass for white. Bearden declined. According to the art historian Mary Schmidt Campbell,

> Light-skinned though he was, doing so [passing] was out of the question for Bearden. Throughout his life, though he was constantly mistaken for white, he was always keenly aware of his identity as a black person. He was also keenly aware of the intellectual and cultural capital, handed down from one generation of his family to the next, of which he was the beneficiary.[6]

Navigating the social and political complexities of race in twentieth-century America would have been especially challenging for Bearden, who, his obituary noted, had been chosen by "the art establishment . . . as its favorite black artist"— a telling qualification. Such a status, with all its attendant pressures, was surely the result of a cultural system that deigned to acknowledge the excellence of only one nonwhite artist at a time.[7] But Bearden wielded this status to broaden the horizons of the "elite" art world and draw attention to work by his Black colleagues: he served as the first art director of the Harlem Cultural Council beginning in 1964; he founded a gallery dedicated to exhibiting the work of young Black artists in 1969; and, with the journalist Harry Henderson, produced *A History of African-American Artists: From 1792 to the Present*, which remains a critical reference on the subject to this day.[8] But as a younger artist, Bearden had bristled at the ways in which an artist's ethnicity or race routinely categorized and limited how their work was perceived. In 1946, in "The Negro Artist's Dilemma," he wrote, "The true artist feels that there is only one art—and it belongs to all mankind. The Negro artist must come to think of himself not primarily as a Negro artist, but as an artist. Only in this way will he acquire the stature which is the component of every good artist."[9] He stated this plainly in an artist's questionnaire for MoMA around 1948; the query "What in your ancestry, nationality or background do you consider relevant to an understanding of your art?" was starkly answered with "Question not valid."[10]

The questionnaire was sent to Bearden following MoMA's acquisition of *He Is Arisen* **[FIG. 5]**, his first work to enter the collection and his first acquisition by a

FIG. 5. Romare Bearden (American, 1911–1988). *He Is Arisen*. 1945. Watercolor and ink on paper, 26 × 19 ⅜″ (66 × 49.2 cm). THE MUSEUM OF MODERN ART, NEW YORK. ADVISORY COMMITTEE FUND

museum. As the title indicates, it is a biblical scene, one of eleven in The Passion of Christ, a series exhibited in 1945 at Kootz Gallery in New York. It was not the first time Bearden had explored religious themes: *The Visitation*, made four years earlier **[FIG. 6]**, depicted the Virgin Mary, pregnant with Jesus, and her cousin Elizabeth, pregnant with John the Baptist. It was, in fact, works like *The Visitation*—large-scale figurative paintings on brown paper—that brought him his first art-world attention. *He Is Arisen* is stylistically distinct, rendered in an angular visual language that would become increasingly abstract in Bearden's midcentury work. Here the faces in profile and the willowy kneeling figures remain recognizable, outlined in black and energized by areas of bold color. It was this work that the scholar Cedric Dover selected to open the section "The Modern Manner" in his 1960 book *American Negro Art*, a major achievement in what was then a relatively unstudied field.[11] By the time the book was published, Bearden had completed *The Silent Valley of Sunrise* **[FIG. 7]**, a very different painting, in a style that would be more typical of his works in the 1950s and early 1960s. Evocatively titled, it is completely abstract, with rich color both surrounding and punctuating a gray mass at its center. The work's focus is not narrative or linear but rather, as Bearden noted, "flat space, flatness, the space and the volumes arrived at through something going over something else."[12] The dynamic of his experiments with oil paint, a medium with which he had struggled, is laid bare on the surface of this work: by combining materials that do not mix—thinned oil paint and casein, a water-based medium—he produced pools of color and areas of dripping, staining, and bubbling.[13]

He Is Arisen and *The Silent Valley of Sunrise* are drastically different works that bookend a tumultuous period of Bearden's life: fifteen years of experimenting, studying, and searching for his path as an American artist. In 1948, the dealer Samuel Kootz, whose support had been instrumental for Bearden's early success, closed his gallery; he reopened it, in 1949, with a new direction that brought his professional association with Bearden to an end. Kootz continued to work with Robert Motherwell and Adolph Gottlieb, and he added Jackson Pollock and Mark Rothko to his roster in order to focus on the Abstract Expressionist work being embraced by the New York art world to the exclusion of other practices—an art-historical moment that continues to overshadow the diversity of American art made at the time. "The withdrawal of support from so highly esteemed a dealer as Samuel M. Kootz must have been a serious blow," the curator Ruth Fine has noted, "causing [Bearden] to rethink priorities and his situation as a painter."[14] In fact, this development confirmed something he had already sensed. "What distressed him more," Campbell wrote, "was his gradual erasure from the New York art world."[15] Deeply committed as he was to work that was unlike what was being celebrated in galleries, museums, and the popular press, Bearden—unsurprisingly—withdrew from the public eye. In 1950 he went to Paris, and for five months he studied at the Sorbonne, visited the Louvre,

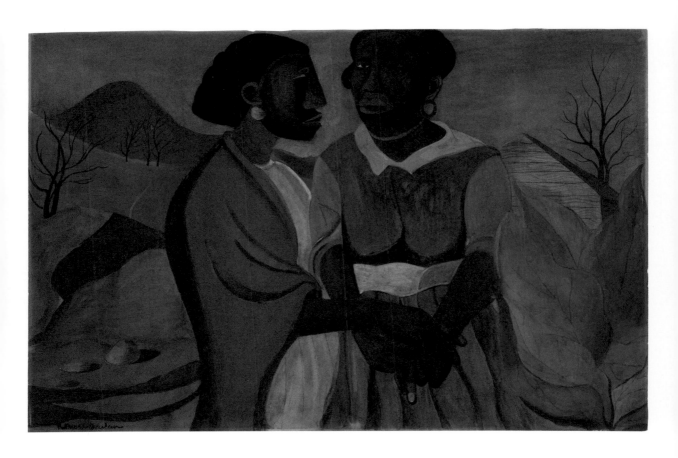

FIG. 6. Romare Bearden (American, 1911–1988). *The Visitation.* 1941. Gouache, ink, and pencil on colored paper, 30½ × 46½" (77.5 × 118.1 cm). THE MUSEUM OF MODERN ART, NEW YORK. GIFT OF ABBY ALDRICH ROCKEFELLER (BY EXCHANGE). ACQUIRED WITH THE COOPERATION OF THE ESTATE OF NANETTE BEARDEN AND THE ROMARE BEARDEN FOUNDATION WHOSE MISSION IS TO PRESERVE THE LEGACY OF THE ARTIST

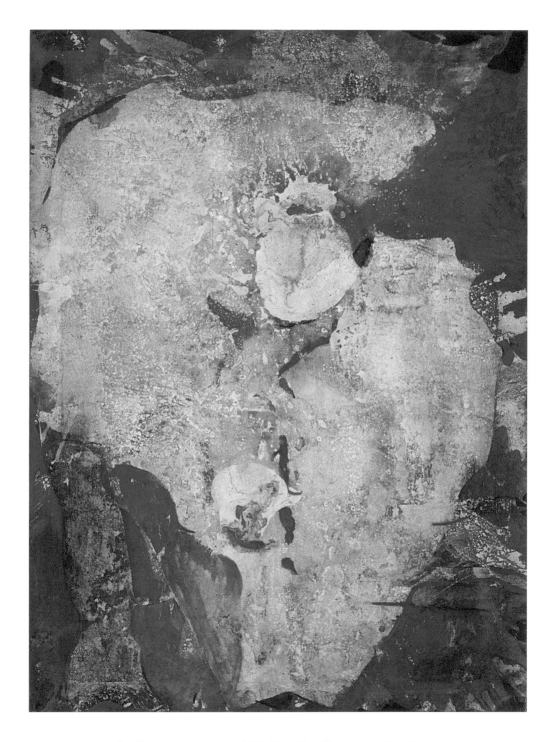

FIG. 7. Romare Bearden (American, 1911–1988). *The Silent Valley of Sunrise.* 1959. Oil and casein on canvas, 58⅛ × 42" (147.5 × 106.5 cm). THE MUSEUM OF MODERN ART, NEW YORK. GIVEN ANONYMOUSLY

and immersed himself in art and music. In the city's rich cultural community, he met artists such as Pablo Picasso and Constantin Brancusi and writers such as Richard Wright and James Baldwin. He did not, however, make much art in Paris, nor did he resume his artistic practice when he returned to New York. Instead, he focused once again on earning a living, resuming his casework for the city's Department of Social Services (a full-time position he held for most of his career) in a new assignment with the Romani community in Brooklyn, and he also found some success as a songwriter—his pop hit "Seabreeze," recorded by Billy Eckstine in 1954, was used in a Seagrams commercial. But something critical to Bearden's sense of self seems to have—at the very least—been missing. His distance from his art practice and the stress of his jobs, as well as the demands of caring for his aging father, took their toll: around 1956, Bearden was admitted to Bellevue Hospital after an episode in which, as he later said, he "blew a fuse."[16] Nanette Rohan, whom Bearden married in 1954, was his savior in this period of crisis, a partner in both work and life. Through Nanette, Bearden met the Madison Avenue art dealer Laura Barone, who in 1955 hosted what would be his only solo exhibition in that decade. Nanette also moved their home and his studio downtown, away from the musicians and songwriters he knew in Harlem, to Chinatown. With this move and her unflagging support, she encouraged him to make visual art again.

Bearden began, he told Dover, with the goal of "trying to find out what there is in me that is common to, or touches, other men. It is hard to do and realize," and he found this commonality in a subject he cherished, and which he knew intimately: Black American life.[17] Although he had previously rejected the idea that his work had to reflect his personal identity and his community's needs and conditions, his artistic breakthrough is tied to his embrace of it as a subject both specific and universal, tied to the kinds of questions about life and its meaning that arose in the years after the horrors of World War II.

The story of how collage became Bearden's signature medium has taken on mythical proportions, in part because of its incidental beginnings. In July 1963, before the historic March on Washington for Jobs and Freedom, Bearden and Woodruff convened a group of Black artists (which would later be known as Spiral) to talk about how they might politically and artistically support their sociopolitical moment. Their discussion turned to the question of a "Black art"— did it exist? Was art made by Black artists necessarily Black art? Would it have to be figurative or to have a certain style? Bearden, of course, had already made his views on the matter clear in his writing and in his work, which thus far had ranged from the realistic to the experimentally abstract, but he was eager to have this gathering of artists result in more than an argument. He proposed that they collaborate on a work, and collage seemed to him the appropriate technique, with disparate parts brought together in an overall composition that could be

politically relevant as well as metaphorical—a symbol of the teamwork he hoped for among the artists and opposing societal factions. The collaboration never materialized, but for Bearden the possibilities of collage took hold, leading him to the medium in which he would create his most groundbreaking and celebrated works—works that, according to Fine, "should be considered monuments in both Bearden's oeuvre and in American art of the early 1960s."[18]

With pictures, shapes, and patterns cut from myriad sources, Bearden made images that are intelligible but which transcend simple figuration. The subject of *The Conjur Woman* [FIG. 8] is clearly and centrally defined. Her face is assembled from mismatched but identifiable pieces, and the shape of her body is distinct from a frenetic background of overlapping branches and brush. Bearden had known such women in his childhood in Mecklenburg County, North Carolina; the subject matter was personal, and the work a memory of a disappearing way of life:

> [The title comes] from these women, now hardly any more exist, who were part of the Afro-American community, especially in the rural South. . . . The Conjur Woman was essential, people went to her for medication and advise on health and personal affairs, but she was also feared, in that through her knowledge of certain herbs, roots, and mysterious practises, she could put a spell, or a "conjur" on a person. Yet, one would go to her for help in removing such a spell.[19]

The birds clustered around the figure and the large black hand hovering behind her shoulder add an otherworldly quality to an already haunting image in which carefully composed fragments capture a being that exists between spiritual planes. But Bearden's versatile technique was just as suited to frenetic city streets. In *The Dove* [FIG. 9], rectangular areas of brickwork, a vertical lamppost, and a defined curb situate the scene on a New York sidewalk. Figures in various states of completion and scale weave in and out of fractured buildings and sit on stoops. Manicured nails hold a cigarette; a white sneaker floats above the crosswalk; the face of the artist William T. Williams peers thoughtfully out of a window in the work's upper-right quadrant.[20] The peaceful connotation of the title feels ironic: the titular dove, perched on a doorframe at the top of the picture, seems overwhelmed by the people, animals, and city life that surround it.[21] Through the rupture inherent in collage, Bearden evokes two entirely different scenes with entirely different emotional charges—the stillness of a mystic figure in the rural South, the explosive energy of an urban thoroughfare.

Bearden showed these intimate, finely crafted works at Cordier & Ekstrom, his new New York gallery, in October 1964, but what drew the attention of critics and visitors were large photostats of the collages, which he called Projections [FIG. 10].[22] In stark tones of black and white, most of them measuring around

FIG. 8. Romare Bearden (American, 1911–1988). *The Conjur Woman*. 1964. Cut-and-pasted printed paper and gouache on board, 12⅛ × 9⅜" (30.6 × 23.7 cm). THE MUSEUM OF MODERN ART, NEW YORK. BLANCHETTE HOOKER ROCKEFELLER FUND

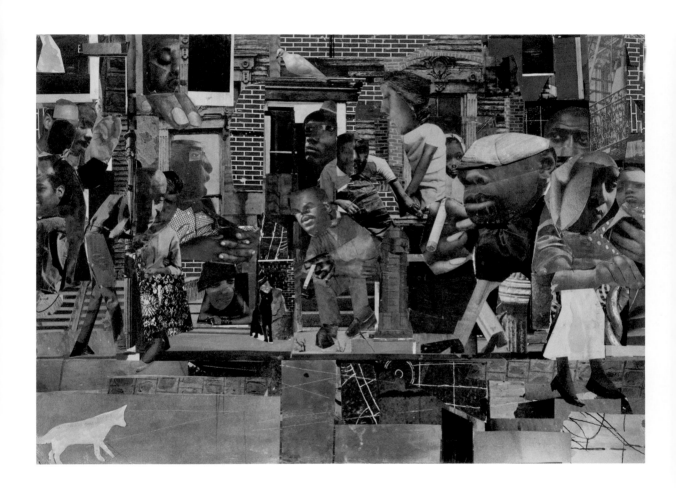

FIG. 9. Romare Bearden (American, 1911–1988). *The Dove.* 1964. Cut-and-pasted printed paper, gouache, pencil, and colored pencil on board, 13 ⅜ × 18 ¾" (33.8 × 47.5 cm). THE MUSEUM OF MODERN ART, NEW YORK. BLANCHETTE HOOKER ROCKEFELLER FUND

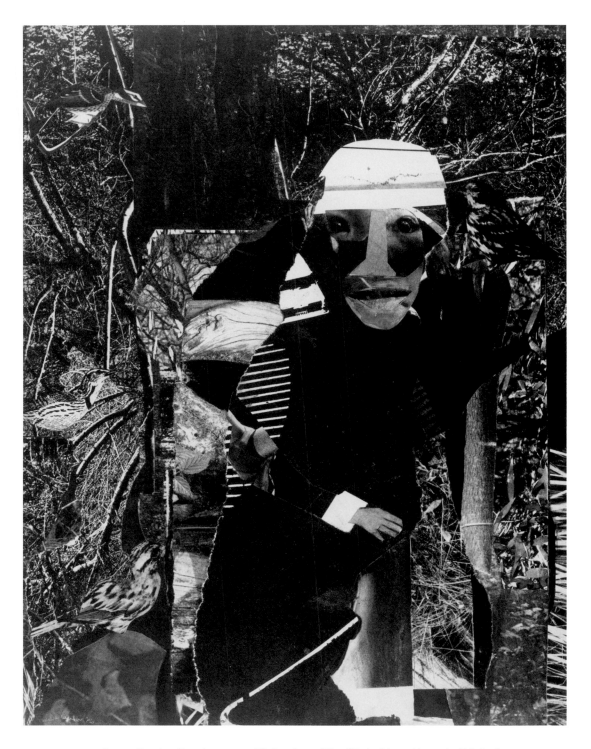

FIG. 10. Romare Bearden (American, 1911–1988). *Prevalence of Ritual/Conjur Woman No. 1.* 1964. Gelatin silver print (photostat), 36 ⅝ × 28 ⅜" (93 × 72.1 cm). Edition: 1/6. THE MUSEUM OF MODERN ART, NEW YORK. PURCHASE

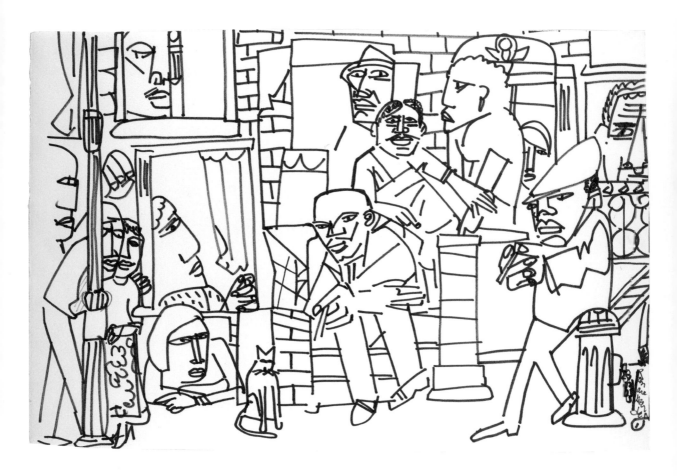

FIG. 11. Romare Bearden (American, 1911–1988). *The Street (Composition for Richard Wright).* c. 1977. Felt-tip pen on paper, 19 1/16 × 27 13/16" (48.4 × 70.7 cm). NATIONAL GALLERY OF ART, WASHINGTON, DC. GIFT OF WERNER H. AND SARAH-ANN KRAMARSKY AND COLLECTORS COMMITTEE FUND

35 by 28 inches (89 by 71.1 cm), they are a very different kind of work. Despite the medium's inherent flatness, they more aggressively enter the viewer's space. The nuanced differences between types of paper and the cut or torn edges of found imagery are less visible than they are in the originals, but the elements of contrasting tones and patterns come to the fore, and the photomontage technique adds a cinematic feel. Arne Ekstrom noted at the time that even though the widely circulating photographs of the Civil Rights Movement, of crowds protesting inequity and demanding justice, had prepared viewers to see works populated by Black Americans, the works are far from documentary: "They are really extraordinary and constitute a sort of re-living and re-telling of his memories as a Negro. . . . In these days of civil rights strife they are, on the sociological side, a unique statement of pride in tradition, dramatic in many instances but never a form or protest of agitation. Artistically they are most remarkable."[23] The Projections are not merely reproductions of previous creations but fully realized works in their own right. This rethinking and reworking of images and themes in a variety of mediums and techniques was already present in Bearden's oeuvre, and his use of photostats was not new; he had, as a younger artist, used them to make reproductions of his work, as well as of works by artists he admired:

> When I started to paint in oil, I simply wanted to extend what I had done in watercolor. To do so, I had the initial sketch enlarged as a photostat, traced it onto a gessoed panel, and with thinned color completed the oil as if it were indeed a watercolor. Later on, I read Delacroix's *Journal* and felt that I, too, could profit by systematically copying the masters of the past and of the present. Not wanting to work in museums, I again used photostats, enlarging photography of works by Giotto, Duccio, Veronese, Grünewald, Rembrandt, de Hooch, Manet, and Matisse. I made reasonably free copies of each work.[24]

Bearden brought a twentieth-century sensibility to the age-old art-student's practice of copying historical works. For him, the technique was always generative, reinforcing his faith that fresh knowledge and results would emerge, and his confidence in it was renewed by his shift to collage and the resulting Projections. Among the photographic and hand-drawn copies he regularly made is an ink drawing of *The Dove* that appeared in the *New York Times* in 1977, accompanying an excerpt from Richard Wright's novel *American Hunger* [FIG. 11]. *The Street (Composition for Richard Wright)* hews close to the collage in terms of its content: it is still bounded by a lamppost to the left and a fire hydrant to the right, and the figures are engaged in the same activities in the same positions, but the similarities end there. The drawing omits the bird of the original composition, and the work's overall tone has changed: the disquieting rupture of faces,

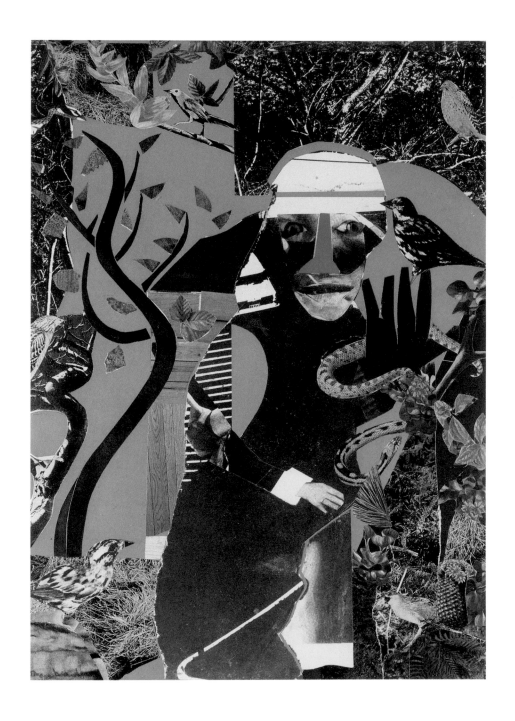

FIG. 12. Romare Bearden (American, 1911–1988). *Conjur Woman.* 1971. Cut-and-pasted printed and colored papers on board, 22¾ × 16¾" (57.8 × 42.5 cm). PRIVATE COLLECTION

bodies, buildings, streets, and sidewalks, has been replaced by a black outline that smoothly unfolds in vertical and horizontal pen strokes that feel assured and deliberate.

Bearden continued to experiment with his collages after the photostat works. In 1971, he cut up a black-and-white reproduction of *The Conjur Woman* and interwove it with vibrant color and defined geometric shapes [FIG. 12]. A snake winds through the woman's hand, bringing to mind the biblical Eve and the temptation of Adam in the Garden of Eden. Bearden's jumping between ways of creating—collage, photographic reproduction, drawing, painting—was as much a part of his work as what he depicted, and it was a thematic process as well, as he strengthened the links between the personal and the universal through the iteration and reinvention of his subject matter. The curator Thelma Golden has noted that Bearden "was concerned not simply with representing black culture but with the far more essential notion of representation—with opening up the authentic and the experiential through formal means."[25] The association of the Conjur Woman with a biblical woman, connected through their access to spirituality, magic, and creation, reveals a new path for accessing the "authentic and the experiential," elevating a figure who would be unknown outside certain African American communities, making Bearden's experience as a Black man wondrously available to all. *The Conjur Woman* asserts the role of Black women in this world and the next; indeed, Black women were one of Bearden's most frequent and tenderly depicted subjects.

Patchwork Quilt's public debut was in *She*, a group exhibition at Cordier & Ekstrom that juxtaposed representations of women in pairs of works that reached across geographies and chronologies. It was shown with a small wood sculpture of a reclining figure, identified as being made by an artist of the Dogon people of Mali [FIG. 13]. The exhibition's evocative mix and match of works echoed Bearden's practice of pulling inspiration and imagery from diverse sources, cultures, and time periods: "Art is always made from other art," he said in 1987, in an interview with Charles H. Rowell, "and you just have to find your place."[26] His figure's straight, extended legs and arm bring to mind the formal rigidity of Egyptian sculpture [FIG. 14], which can make it difficult to see *Patchwork Quilt* as an image of repose;[27] in fact, the work has occasionally been erroneously reproduced as if rotated 90 degrees—as a vertical picture with a figure striding forward.[28] The subject's pose also resembles that of a woman in a photograph by E. J. Bellocq, whose images of prostitutes in the New Orleans red-light district were exhibited at MoMA a month before *Patchwork Quilt* was shown at Cordier & Ekstrom [FIG. 15]; the catalogue for the exhibition was in Bearden's library, and it is entirely possible that he would have seen it.[29] The pose of Bearden's figure has none of the apparent discomfort of Bellocq's, but the two depictions are formally linked by the curved edges of the couches and the striped patterning of

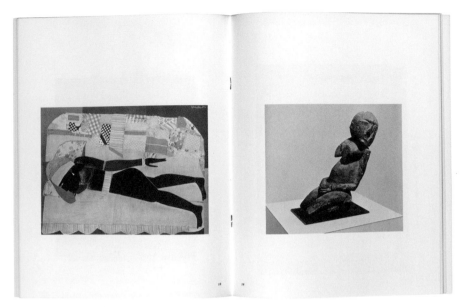

FIG. 13. *She* (New York: Cordier & Ekstrom, 1970), spread with *Patchwork Quilt* and a reclining figure by a Dogon artist of Mali

FIG. 14. Statue of King Menkaura (Mycerinus) and queen. Egyptian, reign of Menkaura, 2490–72 BCE. Greywacke (sandstone), 56 × 22½ × 21¾″ (142.2 × 57.1 × 55.2 cm). MUSEUM OF FINE ARTS, BOSTON

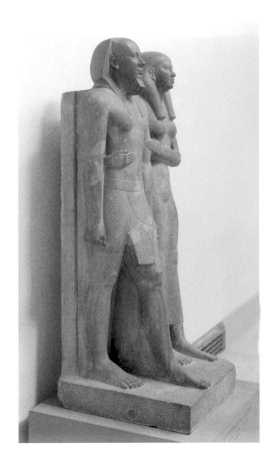

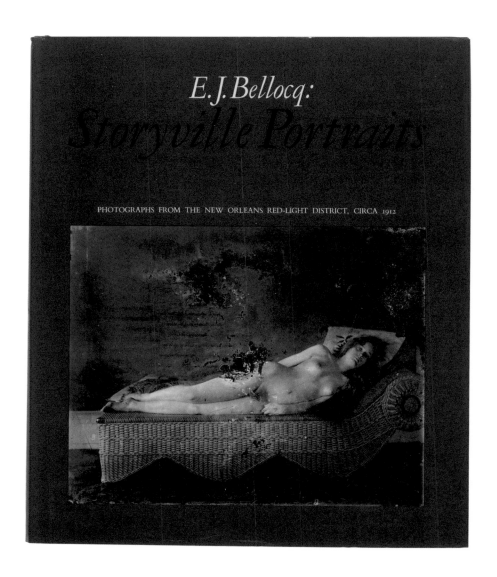

FIG. 15. *E. J. Bellocq: Storyville Portraits; Photographs from the New Orleans Red-Light District, circa 1912* (New York: The Museum of Modern Art, 1970), front cover with untitled image

FIG. 16. Romare Bearden (American, 1911–1988). *Patchwork Quilt* (detail). 1970

wicker and fabric. The geometric planes of the woman's face [**FIG. 16**]—her eye formed by a triangle of negative space that is mirrored by the pasted shape of her hanging earring—recall those of the African masks Bearden frequently used in his collages [**FIG. 17**]. Her most natural-seeming gesture, the resting of her head on her curved arm, has a fluidity similar to that of the nudes of Henri Matisse, whose *Blue Nude II* (1952, **FIG. 18**) was also included in *She*.

In Rowell's 1987 interview, Bearden identifies *Patchwork Quilt*'s majestic, reclining figure as a facet of the specific lived experience of Black people in the

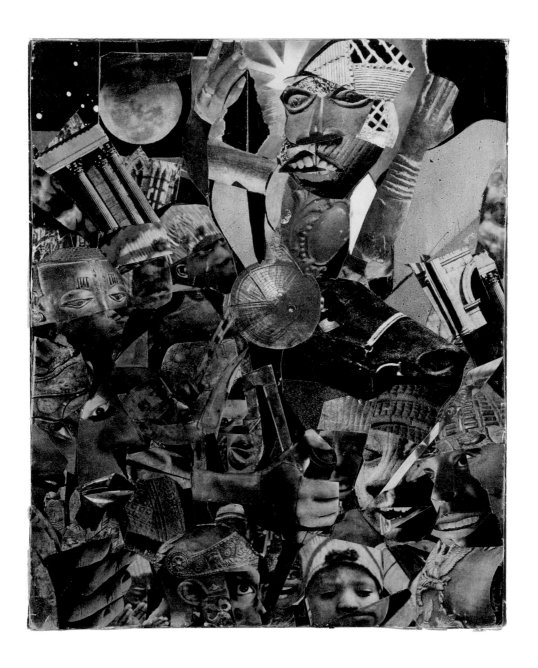

FIG. 17. Romare Bearden (American, 1911–1988). *Sermons: The Walls of Jericho.* 1964. Cut-and-pasted printed paper, paint, ink, and pencil on board, 11 ⅞ × 9 ⅜″ (30 × 23.7 cm). HIRSHHORN MUSEUM AND SCULPTURE GARDEN, SMITHSONIAN INSTITUTION, WASHINGTON, DC. GIFT OF JOSEPH H. HIRSHHORN

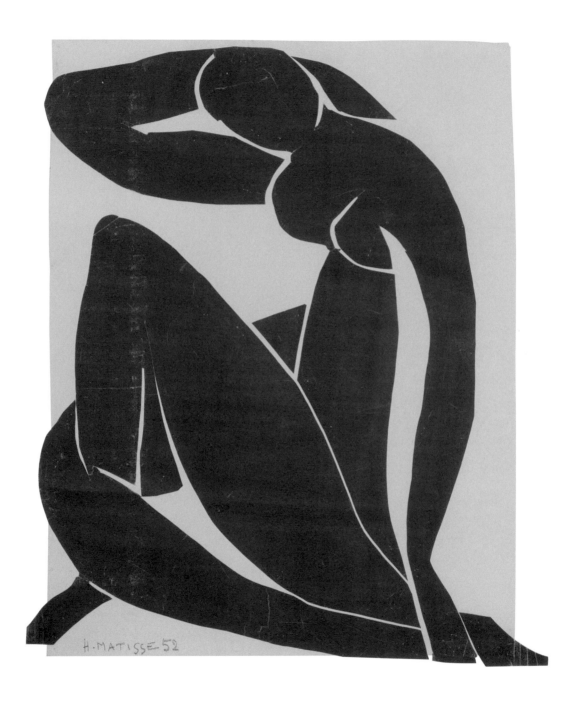

FIG. 18. Henri Matisse (French, 1869–1954). *Blue Nude II.* 1952. Gouache on paper, cut and pasted, on white paper, mounted on canvas, 45¾ × 35″ (116.2 × 88.9 cm). MUSÉE NATIONAL D'ART MODERNE/CENTRE DE CRÉATION INDUSTRIELLE, CENTRE GEORGES POMPIDOU, PARIS. PURCHASE

American South, as well as part of the art-historical lineage of female nudes standing for strength, beauty, and wisdom:

> **Rowell:** What were you trying to achieve with *Patchwork Quilt*?
> **Bearden:** Well, the quilt that Southern people make. People are looking at that kind of art again. It was all around when I was a little boy. . . . It was a lady lying down, but rather than just a nude it was something else. But I don't know what. I'm not saying a queen or something; it was something other . . .
> **Rowell:** . . . than "the nude reclining"?
> **Bearden:** Yeah, like a Rousseau, the great Henri Rousseau's *The Sleeping Gypsy*, with the lion looking at her. She's something else, and to put her into that environment of the patchwork quilt is to bring it back to the experience you've talked about.[30]

Although Rousseau's reclining women—in *The Sleeping Gypsy* (1897, **FIG. 19**) as well as in *The Dream* (1910, **FIG. 20**), whose subject sleeps on a couch, no less—do seem to have surfaced in Bearden's collage, the artist's comments reflect his conceptual approach to *Patchwork Quilt* rather than just his source material. While his earlier collages were assembled predominantly from snippets of reproduced photographs, the woman at the center of *Patchwork Quilt* was formed, like Matisse's *Blue Nude II*, almost entirely of large cut pieces of colored paper (in Bearden's case, commercially produced rather than hand painted). The mostly unbroken form of her body shows mottling around her bust and torso as the result of the surface having been worked, possibly with sandpaper or an electric eraser, to add texture to it. Without found imagery intruding on her form, Bearden's figure becomes, as he said, "something else"—something solid, like an ancient sculpture or a religious icon. Like *The Conjur Woman*, she is otherworldly, but she is also familiar, a woman lounging on a couch in a domestic interior—a theme that appeared in works both before and after *Patchwork Quilt* [**FIGS. 21, 22**]. Bearden frequently used such intimate spaces, inspired by his childhood and family in Mecklenburg County, as backdrops, and by placing this goddess within one of them, he revealed the majesty he saw in those spaces and in the women who populated them. Campbell has described the presence of "these women with their masked faces, hieratic poses, solemn gestures and eyes that refuse pity" as "almost supernatural, almost sacred. . . . They could live comfortably on the frescoed walls of the Pompeiian House of Mysteries or in a small town in North Carolina. All of Bearden's women possess this sacred and profane dualism."[31]

The quilt on which the figure lies is as much of a presence in the work as she is, another character in the story being told. By the time Bearden made

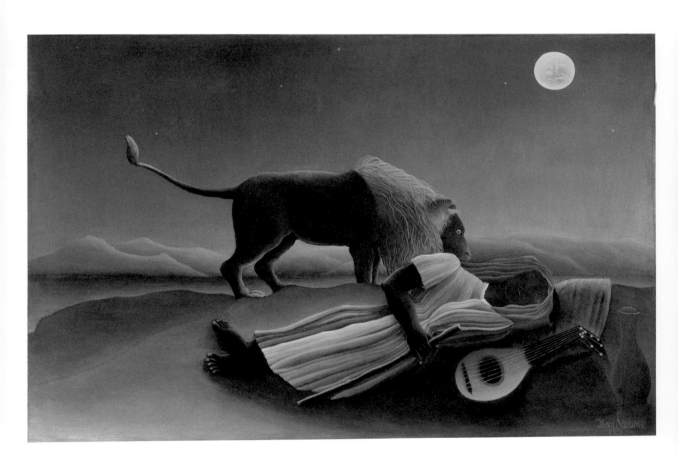

FIG. 19. Henri Rousseau (French, 1844–1910). *The Sleeping Gypsy.* 1897. Oil on canvas, 51″ × 6′ 7″ (129.5 × 200.7 cm).
THE MUSEUM OF MODERN ART, NEW YORK. GIFT OF MRS. SIMON GUGGENHEIM

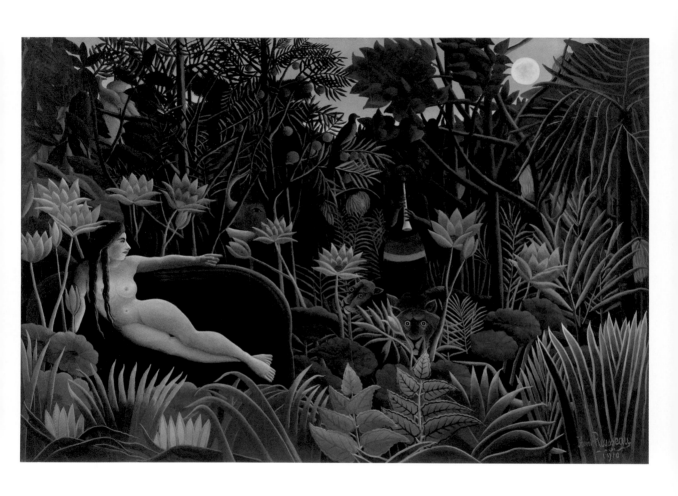

FIG. 20. Henri Rousseau (French, 1844–1910). *The Dream*. 1910. Oil on canvas, 6′ 8½″ × 9′ 9½″ (204.5 × 298.5 cm).
THE MUSEUM OF MODERN ART, NEW YORK. GIFT OF NELSON A. ROCKEFELLER

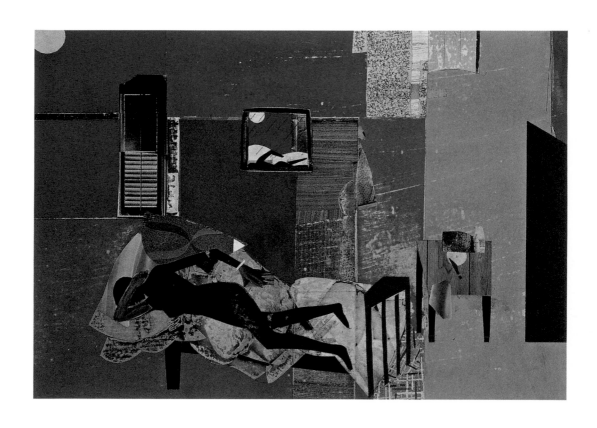

FIG. 21. Romare Bearden (American, 1911–1988). *Two Moons of Luvernia*. 1970. Cut-and-pasted paper with paint and pencil on board, 15 ¾ × 22 ½" (40 × 57.2 cm). PRIVATE COLLECTION

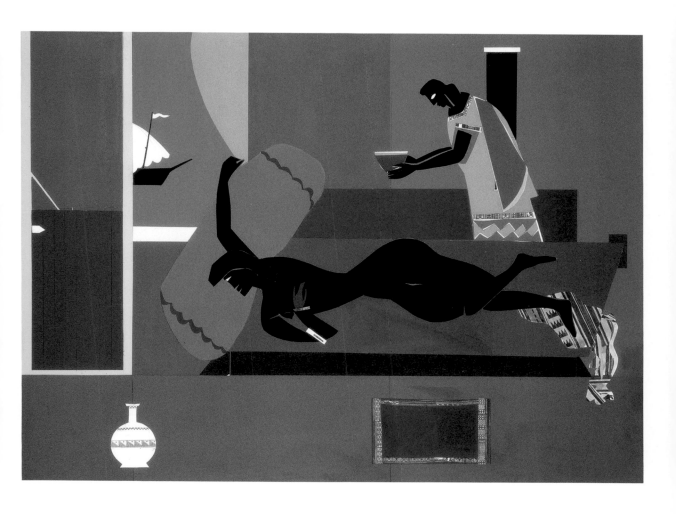

FIG. 22. Romare Bearden (American, 1911–1988). *Odysseus Leaves Circe.* 1977. Cut-and-pasted paper with foil, paint, and pencil on board, 32 × 44" (81.3 × 111.8 cm). PRIVATE COLLECTION

FIG. 23. Romare Bearden (American, 1911–1988). *Black Venus.* 1968. Cut-and-pasted paper on board, 29 ¾ × 40 ³⁄₁₆″ (75.6 × 102.2 cm). MILDRED LANE KEMPER ART MUSEUM, WASHINGTON UNIVERSITY, ST. LOUIS. PURCHASE, CHARLES H. YALEM ART FUND

Patchwork Quilt, he had fully turned to collage as his primary medium and had created a significant body of work with it. Yet this collage is a further exploration of its possibilities, both in the size of the figure and the inclusion of a material other than paper—in this case, cloth. Two large bands of assorted fabrics unfold across the composition, one beneath the figure and one above her. The lower band, excluding the brightly striped ruffle along the bottom edge, seems to be made from worn household fabric, perhaps a bedsheet. Although a faded stripe pattern is visible in the original cloth, Bearden reinforced the lines in a similar color to strengthen their rhythmic effect, especially in areas where they are obscured by a thin coat of pink paint. This somewhat muted section, which recalls the couch in *Black Venus*, an earlier work [**FIG. 23**], contrasts with the bold patches of color in the quilt's upper portion, where reds, pinks, and bold blues activate floral patterns, gingham, and polka dots. The patterns' placement is deliberate: the continuity of the pink, red, and purple stripes that flow down the quilt and reappear at the figure's belted waist demonstrates Bearden's focus on the structural underpinnings of the composition.

As Bearden noted, quilts and textiles, with their carefully constructed abstractions, were in vogue at that moment, being admired in exhibitions such as *African Textiles and Decorative Arts* at MoMA in 1972 [**FIG. 24**][32] and, a year

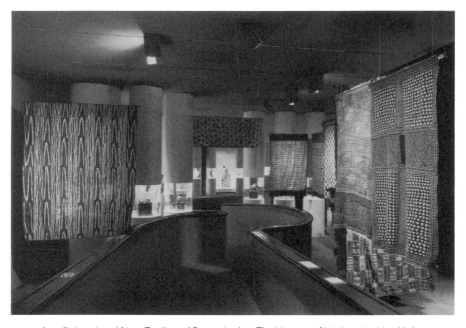

FIG. 24. Installation view, *African Textiles and Decorative Arts*, The Museum of Modern Art, New York, October 11, 1972–January 31, 1973

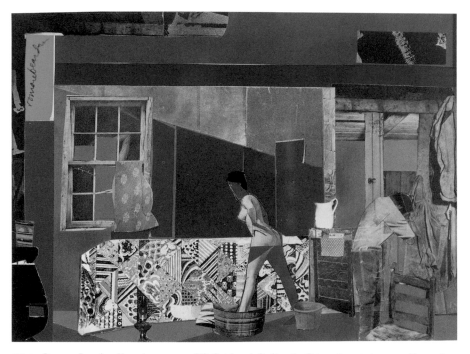

FIG. 25. Romare Bearden (American, 1911–1988). *Patchwork Quilt.* 1969. Cut-and-pasted paper with acrylic on board, 9 × 11 ⅞" (22.9 × 30.2 cm). PRIVATE COLLECTION

earlier, *Abstract Design in American Quilts* at the Whitney Museum of American Art—"The kind of exhibition," one critic wrote, "that prompts us to rethink the relation of high art to what are customarily regarded as the lesser forms of visual expression."[33] Bearden had long acknowledged the artistry of quiltmakers, and quilts had already appeared as rich areas of sensuous color within otherwise drab surroundings in collages he had made before the art world turned its attention to them [**FIG. 25**]. His novel use of real pieces of fabric in *Patchwork Quilt*—his making a quilt as an image of a quilt—is undoubtedly linked to his wife, Nanette, a former model who according to Campbell "often made her own clothes. Fabrics and patterns filled the Canal Street loft along with her magazines . . . and all became visual fodder."[34] *Patchwork Quilt*'s patterned fabrics—perhaps even scraps from the same textiles—turn up in other works from around the same time, such as the muted blue and sharp red ginghams in *The Wood Shed* [**FIG. 26**]. Swatches of Pop art–style printed fabric in flowers and polka dots, set

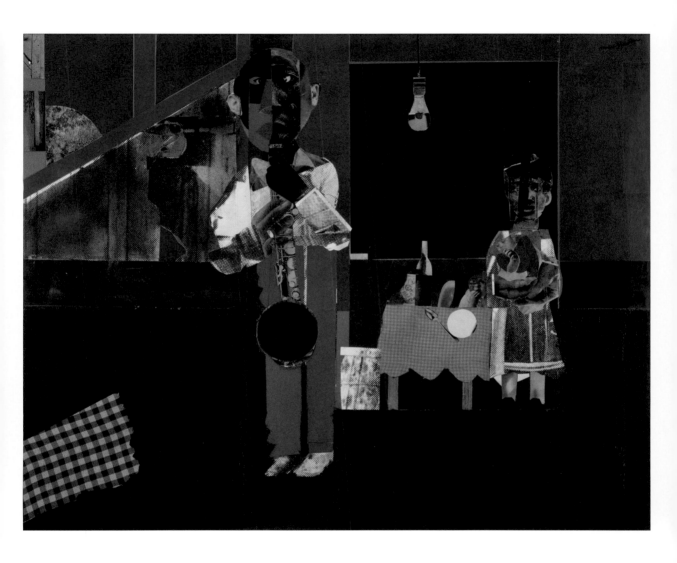

FIG. 26. Romare Bearden (American, 1911–1988). *The Woodshed.* 1969. Cut-and-pasted printed and colored papers, gelatin silver prints (photostats), cloth, pencil, and sprayed ink on Masonite, 40½ × 50½" (102.9 × 128.3 cm).
THE METROPOLITAN MUSEUM OF ART, NEW YORK. GEORGE A. HEARN FUND

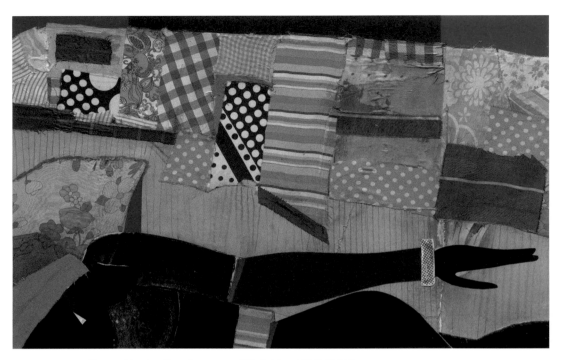

FIG. 27. Romare Bearden (American, 1911–1988). *Patchwork Quilt* (detail). 1970

in among *Patchwork Quilt*'s checks and lines, celebrate cloth's color and whimsy [**FIG. 27**], but in Bearden's subsequent drawings of the work, the emphasis shifts to its geometric patterning. One of these drawings has the feeling of a preparatory sketch [**FIG. 28**], but its accurate depiction of *Patchwork Quilt*'s final composition suggests that it was done afterward—one of many examples of Bearden revisiting and re-creating his works; its notations—"see Nanette for patches" and "take care for leg angles"—may be recollections of his process, or notes for another version. Two additional drawings were included with letters from the artist, one to a Mr. Fox, the other to the writer Albert Murray, Bearden's close friend, thanking him for traveling to one of his exhibitions. Even in these more casual renditions, the quilt's complex abstraction is fully represented [**FIGS. 29, 30**]. This apparent investment in faithful and repeated documentation suggests that for the artist this was one of the work's most significant elements.

Patchwork Quilt is a landmark in Bearden's oeuvre, both for its power as a work of art and for its synthesis of history, personal background, and the formal

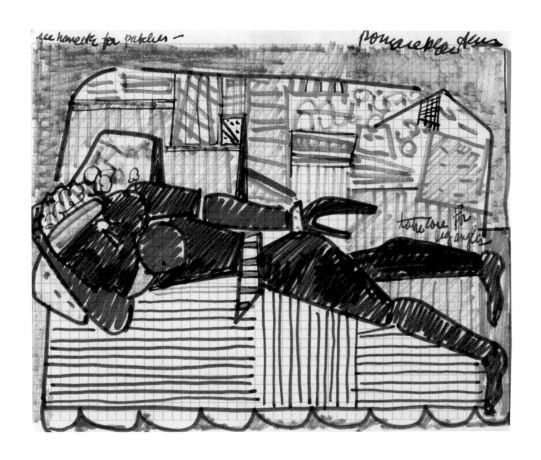

FIG. 28. Romare Bearden (American, 1911–1988). *Patchwork Quilt*. 1970. Felt-tip pen on graph paper, 5 ½ × 6 ½"
(14 × 16.5 cm). THE MUSEUM OF MODERN ART, NEW YORK. GIFT OF LYN AND ET WILLIAMS JR. AND THE FRIENDS OF
EDUCATION OF THE MUSEUM OF MODERN ART

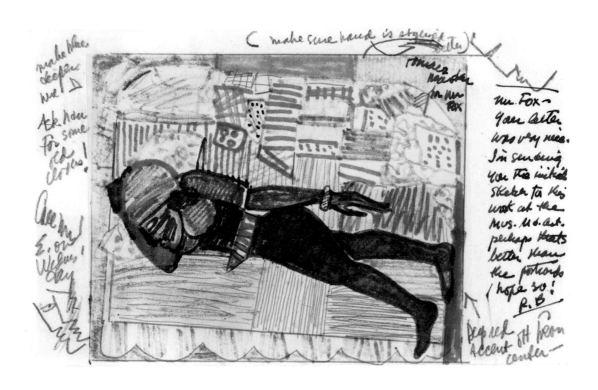

FIG. 29. Romare Bearden (American, 1911–1988). *Patchwork Quilt.* c. 1970. Pencil and ink on paper, 4 7⁄8 × 7 7⁄8"
(12.4 × 20 cm). PRIVATE COLLECTION

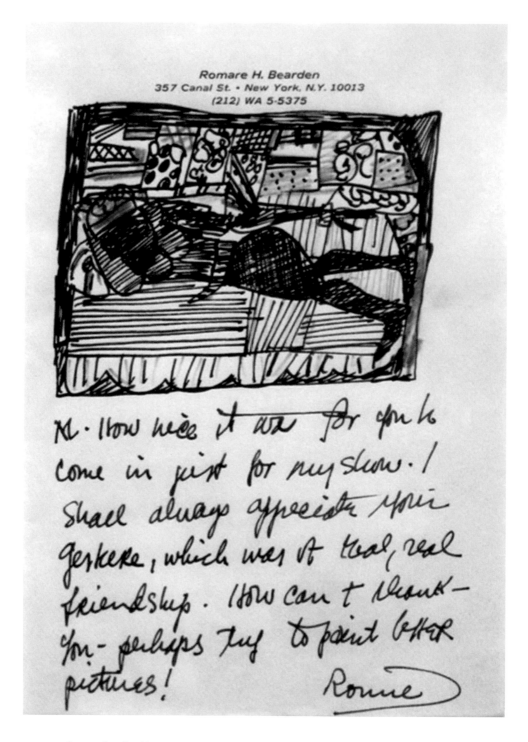

FIG. 30. Romare Bearden (American, 1911–1988). *Patchwork Quilt.* c. 1971. Felt-tip pen on paper, 10½ × 7¼"
(26.7 × 18.4 cm). PRIVATE COLLECTION

issues that concerned him for the whole of his career. It holds an important place in the collection of The Museum of Modern Art as one of the best works by this major twentieth-century artist. Bearden's 1971 retrospective traveled to six venues in the United States, with *Patchwork Quilt* as its star, and since then it has often been on view in MoMA's permanent-collection galleries. In 2011–12 it was included in *Picasso to Warhol: Fourteen Modern Masters*, a selection of major works from MoMA's collection presented at the High Museum, Atlanta, and the Art Gallery of Western Australia, Perth.[35] But despite this and other successes, the artist's story has proved challenging to tell—"History," Campbell has noted, "has had a difficult time with the art of Romare Bearden."[36] His nonlinear artistic development, his resistance to representing a "typical" Black artist, and his boundless generosity make him an outlier in the traditional art-historical narratives of singular geniuses laboring in solitude, insulated from the problems of the world outside their studios; art-historical scholarship must be reinvented in order to study and celebrate work like Bearden's. But for the public and the art world this has already begun, as we take note of Bearden's achievements and recognize his place in mid-twentieth-century art.

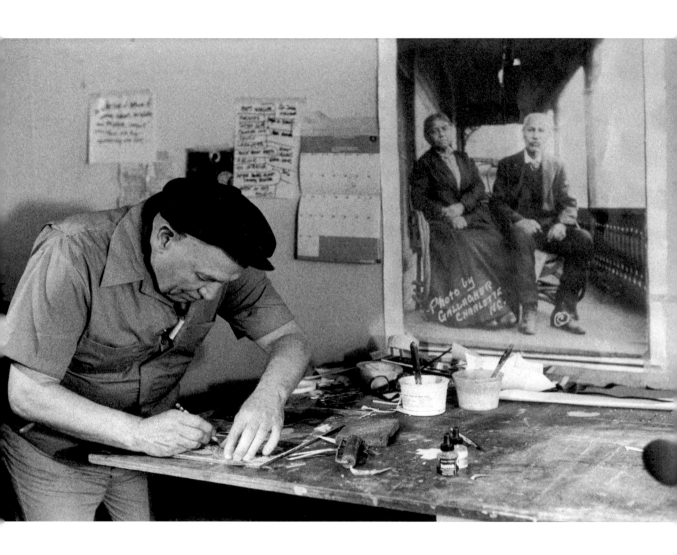

Bearden in his New York studio, with a photograph of Henry and Rosa Kennedy, his great-grandparents, 1980.
Photograph by Frank Stewart

NOTES

1. MoMA's first solo exhibition of a Black artist was *Sculpture by William Edmondson*, October 20–December 1, 1937. See Charlotte Barat and Darby English, "Blackness at MoMA: A Legacy of Deficit," in English and Barat, eds., *Among Others: Blackness at MoMA* (New York: The Museum of Modern Art, 2019), 23. This essay is an extraordinary resource on MoMA's checkered history with Black artists. See also Susan E. Cahan, *Mounting Frustration: The Art Museum in the Age of Black Power* (Durham, NC: Duke University Press, 2016), especially chapter 4.

2. "Gala Preview Held for Bearden, Hunt," *New York Amsterdam News*, April 10, 1971, 18.

3. August Wilson, foreword to Myron Schwartzman, *Romare Bearden: His Life and Art* (New York: Harry N. Abrams, 1990), 8; reprinted in Robert G. O'Meally, ed., *The Romare Bearden Reader* (Durham, NC: Duke University Press, 2019).

4. Schwartzman, *Romare Bearden*, 228.

5. Benny Andrews, letter to Bearden, February 1, 1974, quoted in Barat and English, "Blackness at MoMA," 64.

6. Mary Schmidt Campbell, *An American Odyssey: The Life and Work of Romare Bearden* (New York: Oxford University Press, 2018), 79.

7. C. Gerald Fraser, "Romare Bearden, Collagist and Painter, Dies at 75," *New York Times*, March 13, 1988, 36.

8. Bearden and Harry Henderson, *A History of African-American Artists: From 1792 to the Present* (New York: Pantheon, 1993). For a full chronology, see Rocío Aranda-Alvarado, Sarah Kennel, and Carmenita Higginbotham, "Romare Bearden: A Chronology," in Ruth Fine and Mary Lee Corlett, eds., *The Art of Romare Bearden* (Washington, DC: National Gallery of Art, 2003), 212–46.

9. Bearden, "The Negro Artist's Dilemma," *Critique: A Review of Contemporary Art* 1, no. 2 (November 1946); reprinted in O'Meally, ed., *Romare Bearden Reader*, 96–98.

10. Bearden, artist questionnaire, n.d., MoMA Department of Painting and Sculpture (P&S) Museum Collection (MC) file, Romare Bearden. The questionnaire is undated, but the latest exhibition listed on it was in 1948, at Niveau Gallery, New York.

11. Cedric Dover, *American Negro Art* (Greenwich, CT: New York Graphic Society, 1960), 161, plate 81.

12. Bearden, in Schwartzman, *Romare Bearden*, 186.

13. Tracy Fitzpatrick, *Romare Bearden: Abstraction* (Purchase, NY: Neuberger Museum of Art, 2017), 28–29.

14. Fine, "Romare Bearden: The Spaces Between," in Fine and Corlett, eds., *Art of Romare Bearden*, 21.

15. Campbell, *American Odyssey*, 167.

16. Bearden, in Campbell, *American Odyssey*, 189.

17. Dover, *American Negro Art*, 49.

18. Fine, "The Spaces Between," 31. At that moment in history, many artists were turning to collage. Although Bearden isn't mentioned in Branden W. Joseph's *Random Order: Robert Rauschenberg and the Neo-Avant-Garde* (Cambridge, MA: MIT Press, 2003), its discussion of collage and of the cultural moment provides a context for understanding Bearden's work in that medium.

19. Bearden, questionnaire, December 5, 1976. Department of Drawings and Prints Object File, Romare Bearden, The Conjur Woman.

20. I thank the artist William T. Williams, and the gallerists Michael Rosenfeld and halley k harrisburg for bringing this to my attention. Valentina Spalten, email to the author, June 2, 2017. MoMA Department of Drawings and Prints Object File, Romare Bearden, The Dove.

21. "On the top center of the work, there is a pigeon, or a dove, and it (that is the title) is a rather ironic comment on the total ambience of the scene." Bearden, questionnaire, December 5, 1976. MoMA Department of Drawings and Prints Object File, Romare Bearden, The Dove.

22. *Romare Bearden: Projections*, Cordier & Ekstrom, New York, October 6–24, 1964. I thank my MoMA colleague Lee Ann Daffner, Andrew W. Mellon Foundation Conservator of Photographs, for her expertise on photostats.

23. Arne Ekstrom, letter to Darthea Speyer, September 25, 1964, quoted in Fine, "The Spaces Between," 41.

24. Romare Bearden, "Rectangular Structure in My Montage Paintings," *Leonardo* 2, no. 1 (January 1969); reprinted in O'Meally, ed., *Romare Bearden Reader*, 122.

25. Thelma Golden, "Projecting Blackness," in *Romare Bearden in Black-and-White: Photomontage Projections, 1964* (New York: Whitney Museum of American Art, 1997), 40.

26. Bearden, "Inscription at the City of Brass," interview by Charles H. Rowell, *Callaloo* 36 (Summer 1988): 439.

27. "Here a woman on a patchwork quilt, in possibly a southern cabin, is given overtones that relate her to ancient Benin and Egypt." Bearden, object questionnaire 1976. MoMA, P&S MC file, Romare Bearden, Patchwork Quilt.

28. *Patchwork Quilt* was reproduced incorrectly in Bearden's *New York Times* obituary. Fraser, "Romare Bearden, Collagist and Painter, Dies at 75."

29. See Fine, "The Spaces Between," 92–95; and Patton, *Romare Bearden: Narrations* (Purchase, NY: Neuberger Museum of Art, 2002), 11.

30. Bearden, "Inscription at the City of Brass," 439.

31. Campbell, *Mysteries: Women in the Art of Romare Bearden* (Syracuse, NY: Everson Museum of Art of Syracuse and Onondaga County, 1975), n.p.

32. Judith Wilson, "Getting Down to Get Over: Romare Bearden's Use of Pornography and the Problem of the Black Female Body in Afro-U.S. Art," in Gina Dent, ed., *Black Popular Culture: A Project by Michele Wallace* (Seattle: Bay Press, 1992), 120n7.

33. Hilton Kramer, "Art: Quilts Find a Place at the Whitney," *New York Times*, July 3, 1971, 22.

34. Campbell, *American Odyssey*, 189.

35. *Picasso to Warhol: Fourteen Modern Masters*, High Museum of Art, Atlanta, October 15, 2011–April 29, 2012, and Art Gallery of Western Australia, Perth, June 16–December 3, 2012.

36. Campbell, "History and the Art of Romare Bearden," in Campbell and Patton, eds., *Memory and Metaphor*, 7.

FOR FURTHER READING

Campbell, Mary Schmidt. *An American Odyssey: The Life and Work of Romare Bearden*. New York: Oxford University Press, 2018.

Fine, Ruth, and Mary Lee Corlett. *The Art of Romare Bearden*. Washington, DC: National Gallery of Art, 2003.

Fine, Ruth, and Jacqueline Francis, eds. *Romare Bearden: American Modernist*. Studies in the History of Art 71. Washington, DC: National Gallery of Art, 2011.

Fitzpatrick, Tracy, and Lowery Stokes Sims. *Romare Bearden: Abstraction*. Purchase, NY: Neuberger Museum of Art, 2017.

Gelburd, Gail, Thelma Golden, and Albert Murray. *Romare Bearden in Black-and-White: Photomontage Projections, 1964*. New York: Whitney Museum of American Art, 1997.

O'Meally, Robert G., ed. *The Romare Bearden Reader*. Durham, NC: Duke University Press, 2019.

Schwartzman, Myron. *Romare Bearden: His Life and Art*. New York: Harry N. Abrams, 1990.

Leadership support for this publication is provided by the Kate W. Cassidy Foundation.

Produced by the Department of Publications,
The Museum of Modern Art, New York

Leadership support for this publication is provided by
the Kate W. Cassidy Foundation.

Hannah Kim, Business and Marketing Director
Don McMahon, Editorial Director
Marc Sapir, Production Director
Curtis R. Scott, Associate Publisher

Edited by Emily Hall
Series designed by Miko McGinty and Rita Jules
Layout by Amanda Washburn
Production by Matthew Pimm
Proofread by Aimery Dunlap-Smith
Printed and bound by Ofset Yapımevi, Istanbul

This book is typeset in Ideal Sans.
The paper is 150gsm Magno Satin.

Published by The Museum of Modern Art
11 West 53 Street
New York, NY 10019-5497
www.moma.org

ISBN: 978-1-63345-145-2

Distributed in the United States and Canada by
ARTBOOK | D.A.P.
75 Broad Street
Suite 630
New York, NY 10004
www.artbook.com

Distributed outside the United States and Canada by
Thames & Hudson
181A High Holborn
London WC1V 7QX
www.thamesandhudson.com

Printed and bound in Turkey

PHOTOGRAPH CREDITS

In reproducing the images contained in this publication,
the Museum obtained the permission of the rights
holders whenever possible. If the Museum could not
locate the rights holders, notwithstanding good-faith
efforts, it requests that any contact information
concerning such rights holders be forwarded so that
they may be contacted for future editions.

Unless otherwise noted, works by Romare Bearden are
© 2022 The Romare Bearden Foundation / Artists
Rights Society (ARS) / VAGA, New York.

Digital image courtesy The Estate of Romare Bearden /
Artists Rights Society (ARS) / VAGA, New York: fig. 22.
Digital image © Hirshhorn Museum and Sculpture
Garden, Smithsonian Institution, Washington, DC,
photograph by Lee Stalsworth: fig. 17. Courtesy Jerald
Melberg Gallery, Charlotte, North Carolina: figs. 29, 30.
© Succession H. Matisse / Artists Rights Society (ARS),
New York. Musée National d'Art Moderne/Centre
Georges Pompidou/Paris/France, digital Image © CNAC/
MNAM, Dist. RMN-Grand Palais / Art Resource, NY:
fig. 18. Digital image © The Metropolitan Museum of
Art / source Art Resource, New York: fig. 26. Digital
image © Mildred Lane Kemper Art Museum, Washington
University, St. Louis, photograph by Jean Paul Torno:
fig. 23. Photograph © 2022 Museum of Fine Arts,
Boston: fig. 14. Digital image © 2022 The Museum of
Modern Art, New York, Department of Imaging and
Visual Resources, photograph by George Cserna: fig. 24;
photograph by Robert Gerhardt: figs. 5, 12, 13, 15, 21, 25,
27; photograph by Thomas Griesel: fig. 9; photograph by
Paige Knight: fig. 7; photograph by Jonathan Muzikar:
pp. 2–3, figs. 6, 16, 20, 27; photograph by John Wronn:
figs. 2, 3, 8, 10, 19, 28. Digital image © Board of Trustees,
National Gallery of Art, Washington, D.C., photograph
by Christina Moore: fig. 11. Image © Jan van Raay: fig. 4.
Digital image © Shaw Family Archives, Ltd.: fig. 1.
Photograph © Frank Stewart, courtesy The Romare
Bearden Foundation: p. 41 and back cover.